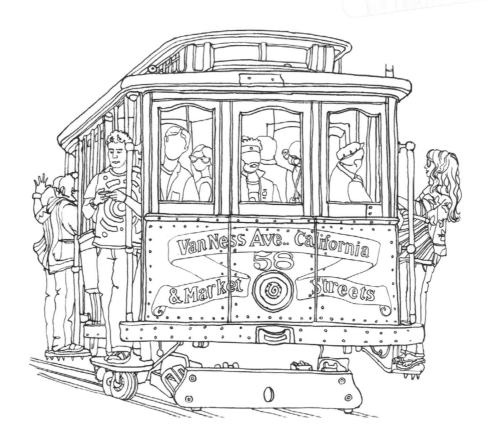

Color
San Francisco

HARPER
DESIGN

An Imprint of HarperCollins Publishers

Color San Francisco

HarperCollins books may be purchased for educational,
business, or sales promotional use. For information please email
the Special Markets Department at SPsales@harpercollins.com.

Published in 2017 by
Harper Design
An Imprint of HarperCollins*Publishers*
195 Broadway
New York, NY 10007

Tel: (212) 207-7000 Fax: (855) 746-6023
harperdesign@harpercollins.com
www.hc.com

Distributed throughout the world in the English language by
HarperCollins Publishers
195 Broadway
New York, NY 10007

ISBN 978-0-06-257426-8

Printed in China

First Printing, June 2017

This book was conceived, designed, and produced by
Ivy Press
Ovest House, 58 West Street, Brighton BN1 2RA, UK

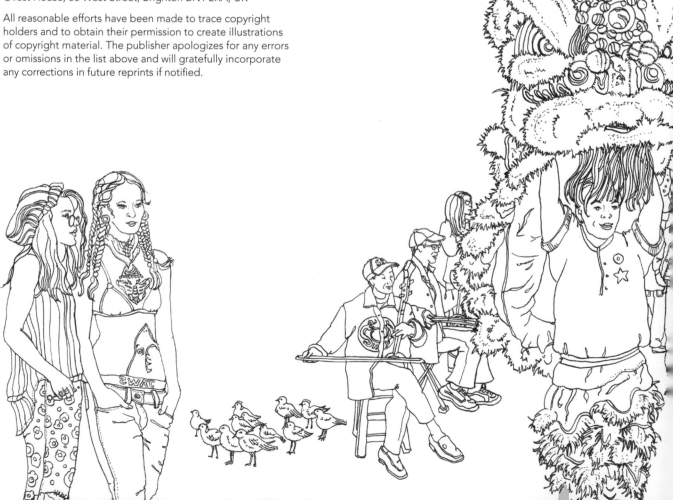

This book belongs to

..

..

..

..

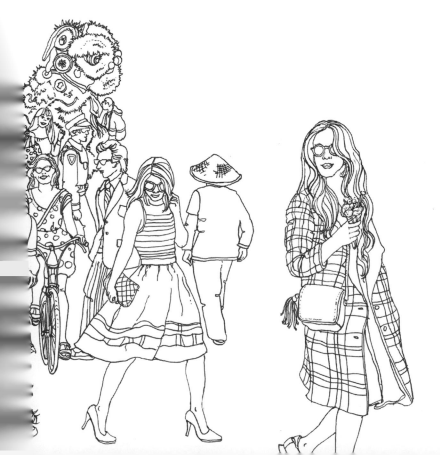

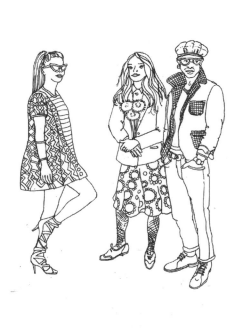

1.

Golden Gate Bridge

7.

The Palace
of Fine Arts

Color
San Francisco

3.

de Young Museum

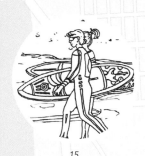

15.

Ocean

Beach

11.

Twin Peaks

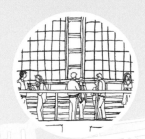

12.

San Francisco Museum
of Modern Art

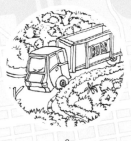

8.

Lombard Street,

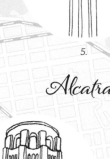

5.

Alcatraz

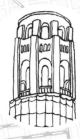

17.

Coit Tower

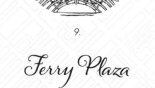

19.

City Lights Bookstore

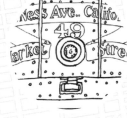

6.

Cable Cars on the California/
Van Ness Line

20.

Fairmont Hotel
Mason Street

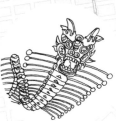

13.

Chinatown

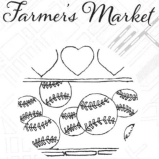

9.

Ferry Plaza
Farmer's Market

14.

The Painted Ladies
of San Francisco

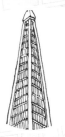

18.

Transamerica Pyramid

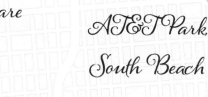

4.

Union Square

2.

AT&T Park,
South Beach

16.

Mission Dolores
Park

10.

Women's Building
Mission District

Introduction

What comes to mind when you picture San Francisco? Perhaps it's the rusty-red towers of Golden Gate Bridge piercing the fog, picturesque cable cars trundling up some of the city's incredibly steep hills, or the vivid line-up of the Painted Ladies—the name given to the city's surviving Victorian houses with their cute gingerbread trim? Or maybe a public reading of Allen Ginsberg's shockingly avant-garde "Howl" at the City Lights bookstore? Or the spacious hall of the old Ferry Building on the port, the soaring rocket-ship shape of the Transamerica skyscraper, or the 360-degree view of the city from the Twin Peaks hills?

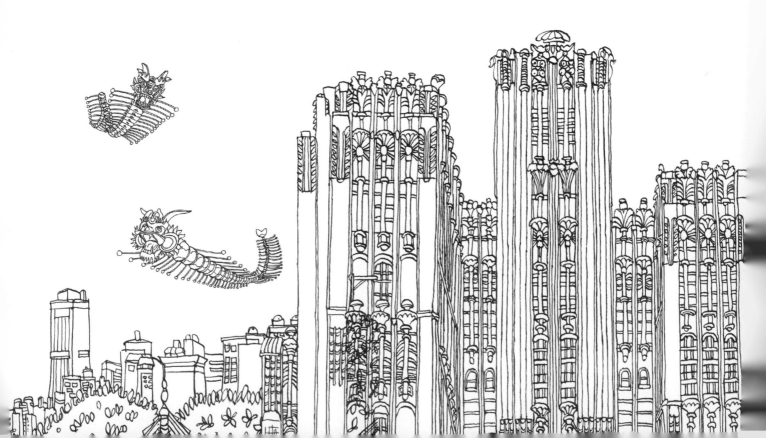

Whatever characterizes San Francisco to you, you'll find it here. *Color San Francisco* offers twenty city vistas, each described in fabulously minute detail, from the Beaux Arts trimmings of the Palace of Fine Arts to the gloriously lavish stacks of produce at Ferry Plaza farmer's market. Nearly every scene is populated with visitors, San Franciscans parading the city's famous laid-back style. All you have to bring is the color. Enjoy.

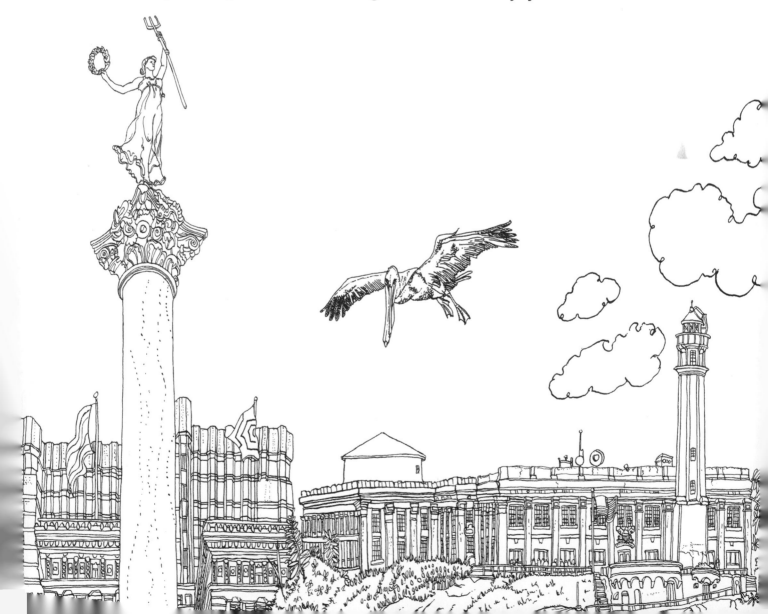

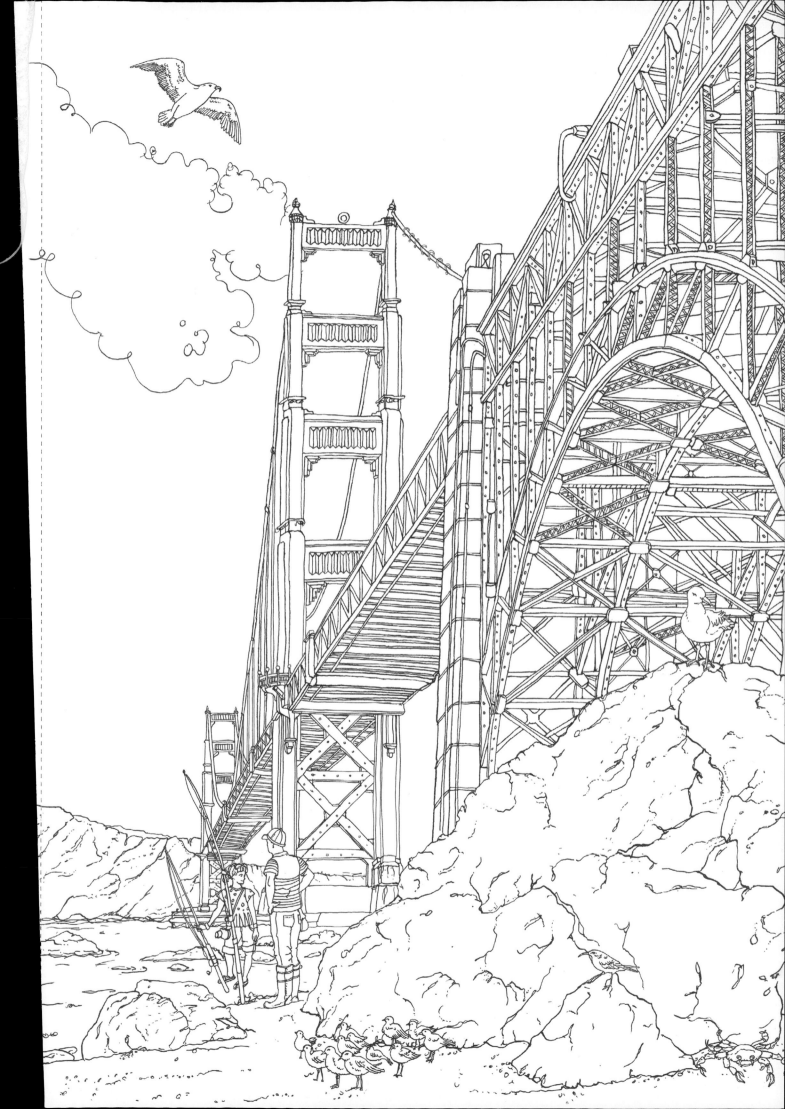

previous page

1.

Golden Gate Bridge

As the Eiffel Tower is to Paris, so the Golden Gate Bridge is to
San Francisco—the icon that, above all others, identifies the city
around the world. A huge single span that links San Francisco with
Marin County across the Golden Gate strait, it was opened in 1937
and offers impressive stats for the bridge enthusiast: its two cables
each stretch over 7,650 feet (2,332 m) and use more than 80,000 miles
(129,000 km) of wire, while the twin towers supporting them soar
to 746 feet (227 m). At the time of its opening, it was the longest
suspension bridge in the world; perhaps even more impressively,
it took only four years to build and came in more than a million dollars
under budget. "International Orange," its particular shade of rusty red,
was chosen not only to work with the bridge's stunning natural setting
but also to make it more visible in San Francisco's frequent fogs.

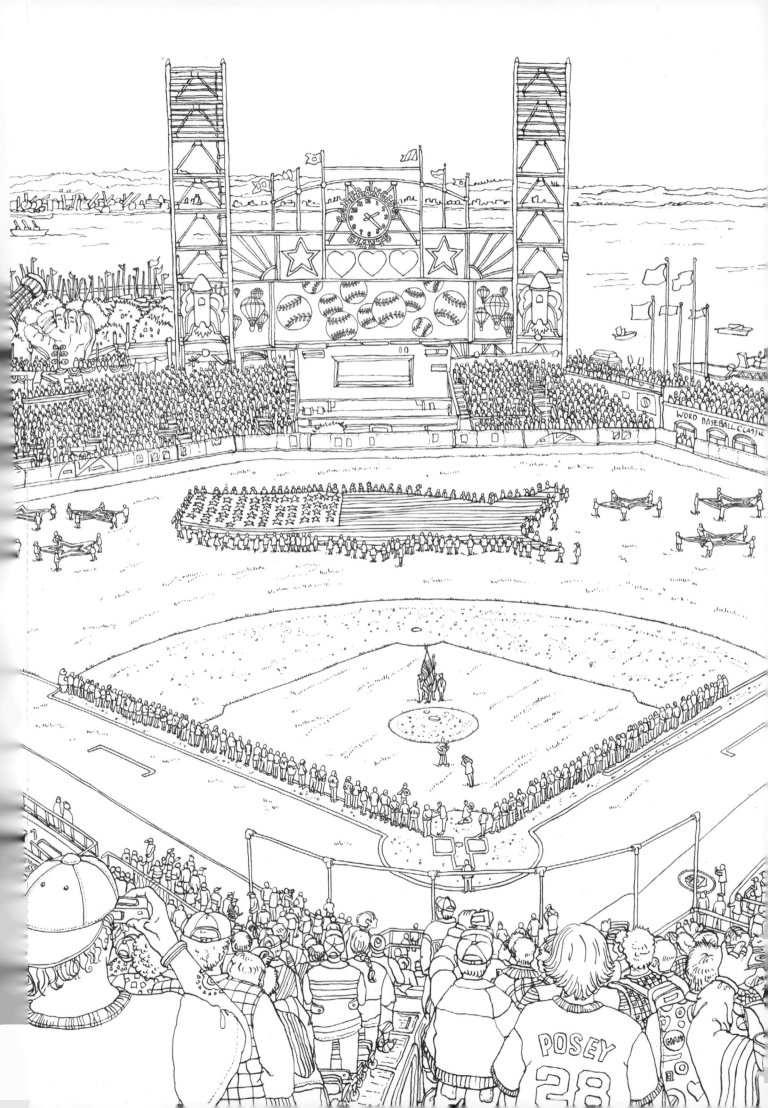

previous page

2.

AT & T Park, South Beach

Like most other American cities, San Francisco has its iconic baseball stadium—and, as in most American cities, it is home to the local team, in this case the San Francisco Giants. The stadium, which sits just next to the bay, is on its third name: earlier versions, dictated by the stadium's franchise, were first Pacific Bell Park, then SBC Park; it finally became AT&T Park in 2006. Although its proximity to the bay can mean that performances are both chilly and foggy, supporters have been known to take to the water in small boats and kayaks during a game in the hope of scooping up a home-run ball.

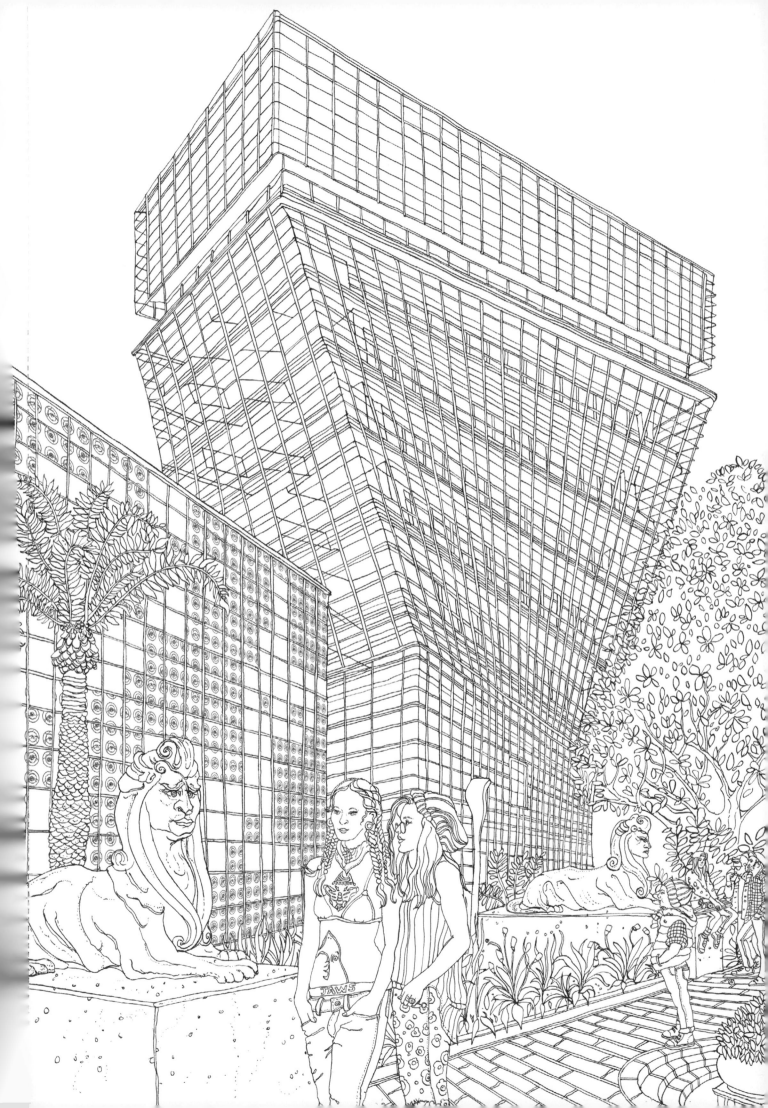

previous page

3.

de Young Museum

Golden Gate Park isn't short of attractions, from the Conservatory of Flowers—the oldest greenhouse in North America—to the herd of bison grazing in their paddock at its western end. But the impressive modern incarnation of the de Young, a museum dedicated to the fine arts founded back in 1895, is one of the most popular. Its striking building, designed by the Swiss architects Herzog & de Meuron and opened in 2005, is faced with 950,000 pounds (431,000 kg) of copper in the form of embossed panels. Inside is one of the best collections of American art anywhere, as well as world-class collections of Oceanic and African pieces and Eastern and Western costumes and textiles. In addition to more than 27,000 works in its permanent care, it's also known for an exciting exhibition calendar, showcasing everyone from Keith Haring to J. M. W. Turner, and from David Hockney to Georgia O'Keeffe.

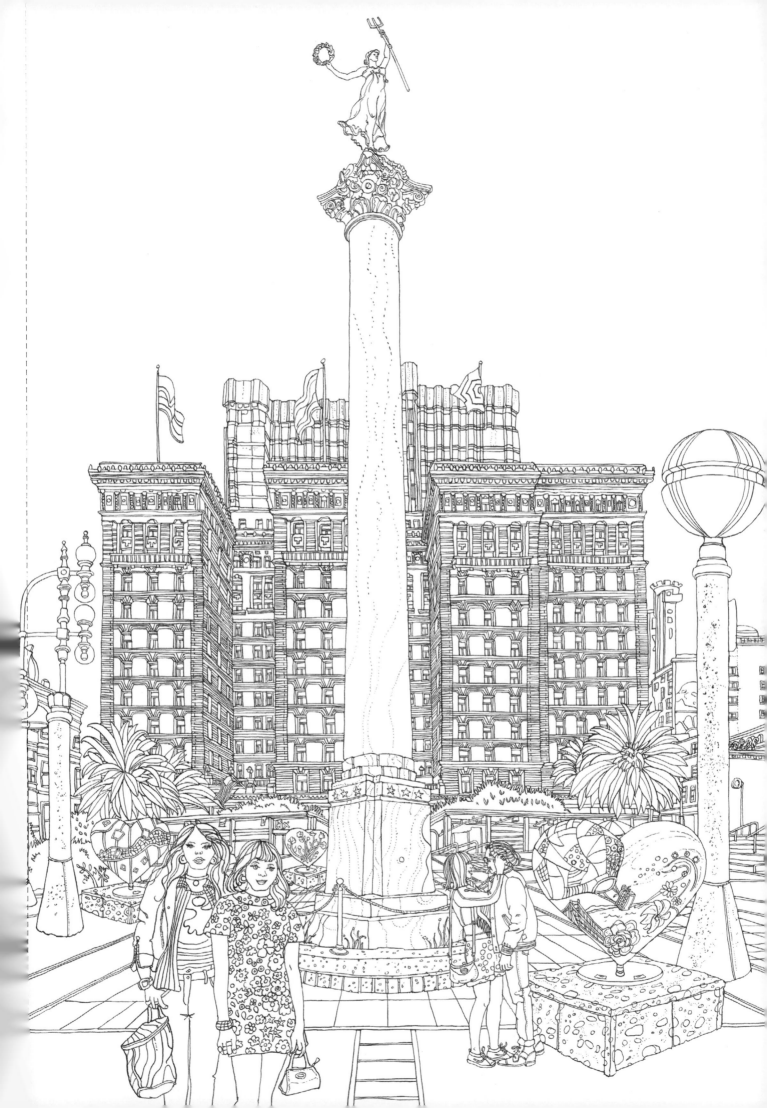

previous page

4.

Union Square

Originally a center for political gatherings, Union Square today is a magnet for tourists, located downtown and central to the shopping and theater districts of San Francisco. The column of the Dewey Monument, dedicated to a hero of the Spanish-American War, and the Hotel St. Francis in the background of the picture, dating from 1904, were two of the few survivors of the devastating 1906 earthquake. The hotel was gutted by fires caused by the earthquake, and the residents and guests were housed in temporary buildings on the square itself while the hotel was rebuilt. The painted hearts that dot the square are part of the Hearts in San Francisco initiative, started in 2004: heart sculptures painted by eminent artists are displayed around the city, then auctioned off to the highest bidder at the end of each year's installation.

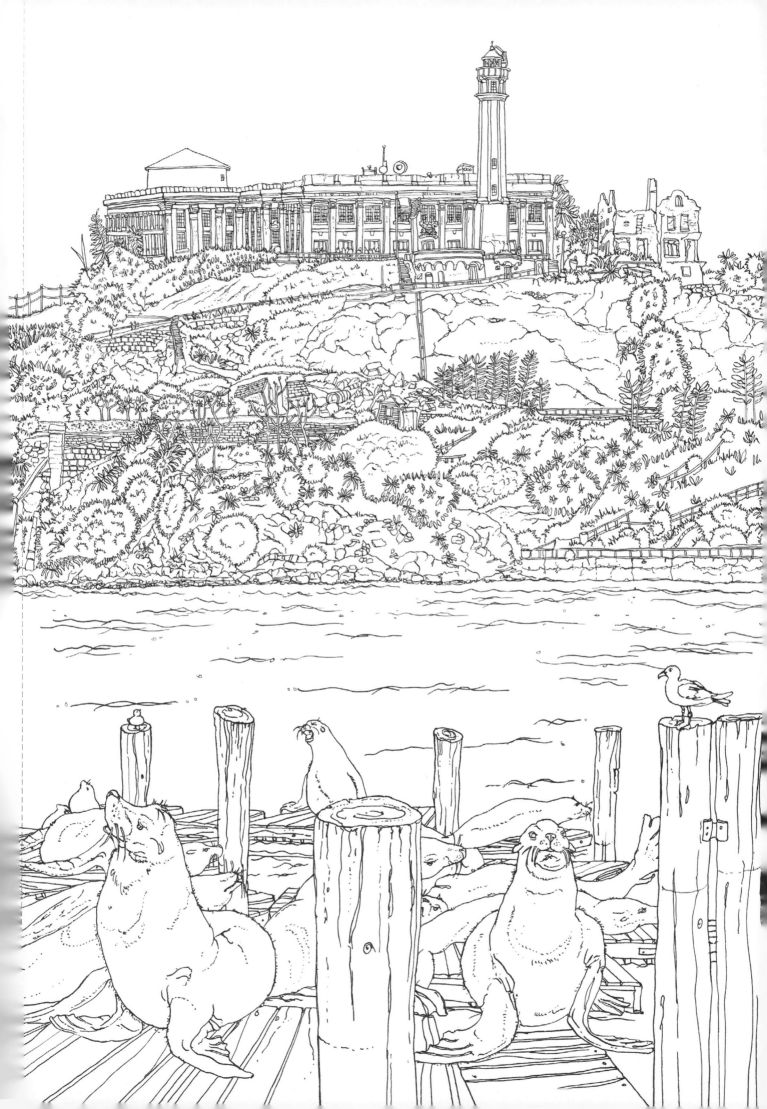

previous page

5.

Alcatraz

More than fifty years after it was closed down as a penitentiary,
the little island of Alcatraz in San Francisco Bay is still best-known
for the period between 1934 and 1963, when it was a federal prison.
It's small—only twenty-two acres—but "the Rock" plays a major part
in American prison myth and legend, fueled by its many appearances
in movies and TV shows. Today, visitors come by boat to look over the
derelict prison buildings and take wildlife tours: the island is home to
many bird species, from night herons to cormorants, and has a unique
plant habitat in which species that were originally cultivated, such as
roses, vines, and sweet peas, have gone extravagantly wild, rioting
among the native grasses and agaves. The island was originally
named the Isla de los Alcatraces (the "Isle of the Gannets") in 1775.

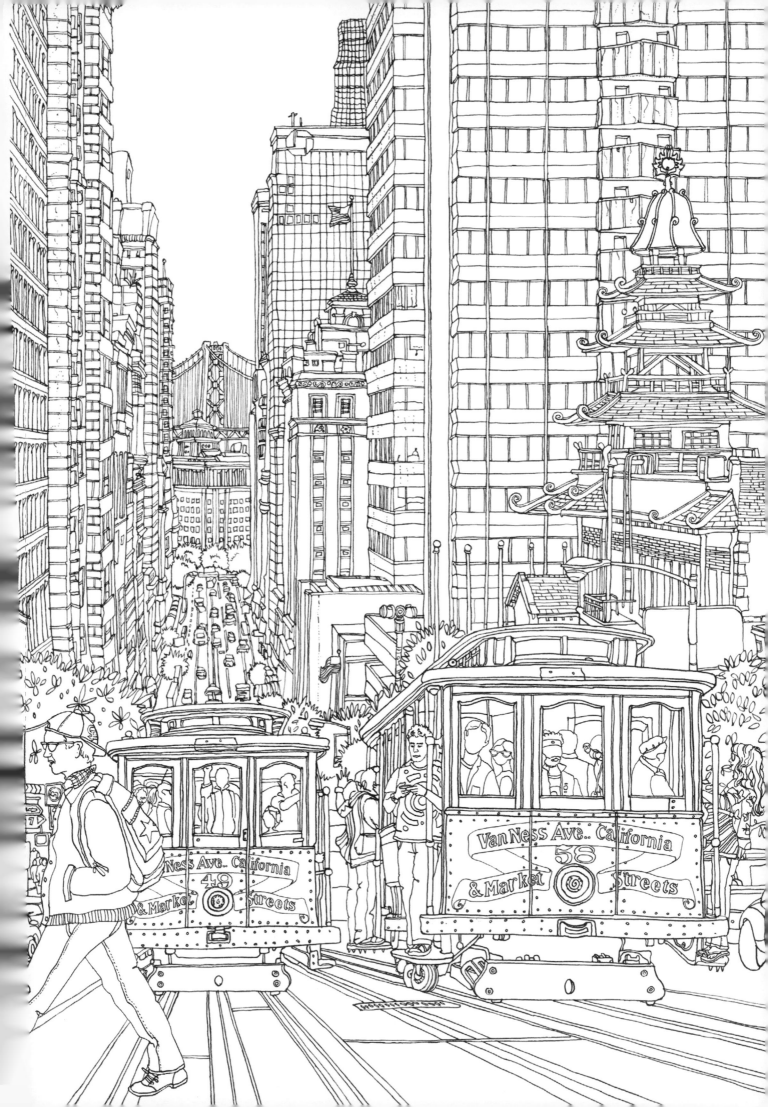

previous page

6.

Cable Cars on the California/Van Ness Line

In their heyday, between 1873 and the 1890s, San Francisco's cable cars ran on twenty-three different lines. The steep hills of the city made cable cars popular; they were well suited to the terrain, which was in places too vertiginous for the streetcars that were in wider use at the time. Today just three routes remain—Powell/Hyde, Powell/ Mason, and California/Van Ness—and although the cars are more used by tourists than by residents, a ride up some of San Francisco's steeper streets remains a thrill; bolder passengers can stand outside, on the footboards of the vehicles, and hang on tight. The cable cars are on the National Register of Historic Places—surely the only "places" that are perpetually on the move.

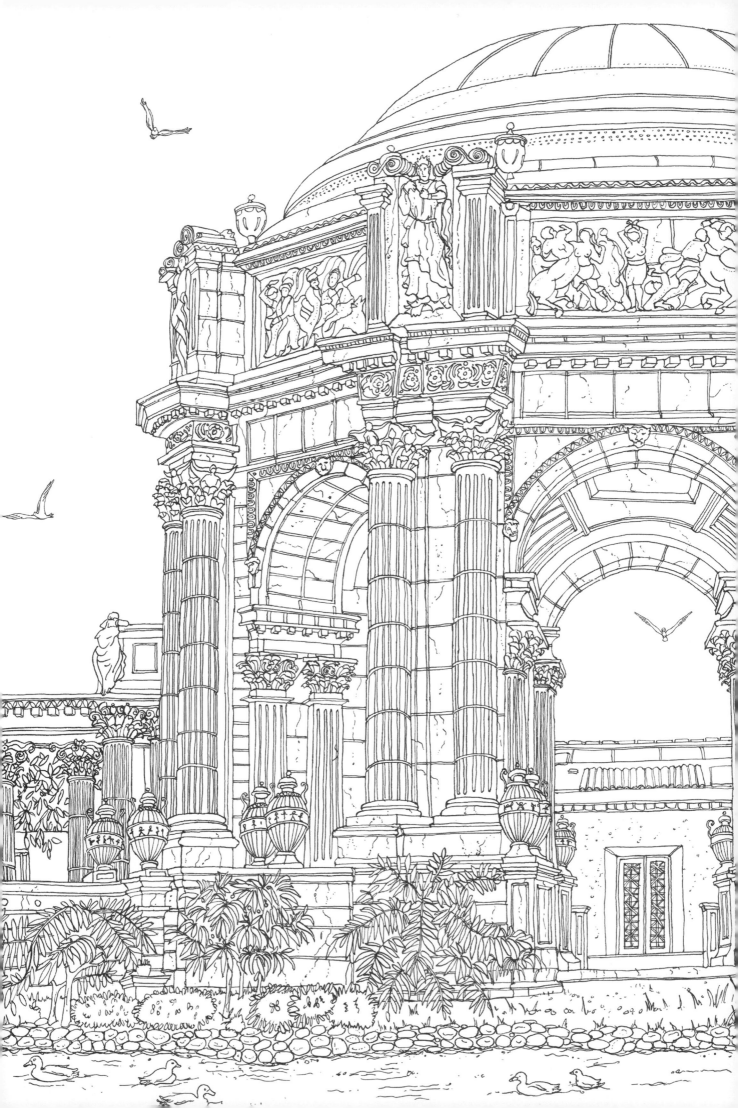

previous page

7.

The Palace of Fine Arts

The rotunda of the Palace of Fine Arts is one of the most familiar landmarks in San Francisco. Yet this relic of the wildly successful Panama–Pacific International Exposition of 1915 isn't even the original building. None of the structures of the exposition were intended to last, but the Greco-Roman style rotunda and the "palace" that formed a semi-circular sweep behind it, facing a small man-made lake, were so popular that they were allowed to remain when the rest of the park buildings were demolished. By the early 1960s, the rotunda—made from wood, plaster, and painted canvas—was crumbling, and in 1965 it was reconstructed in concrete, matched in every detail. Today, it remains well loved, and is used as a movie and TV set, for wedding photographs, and as a bucolic picnic spot.

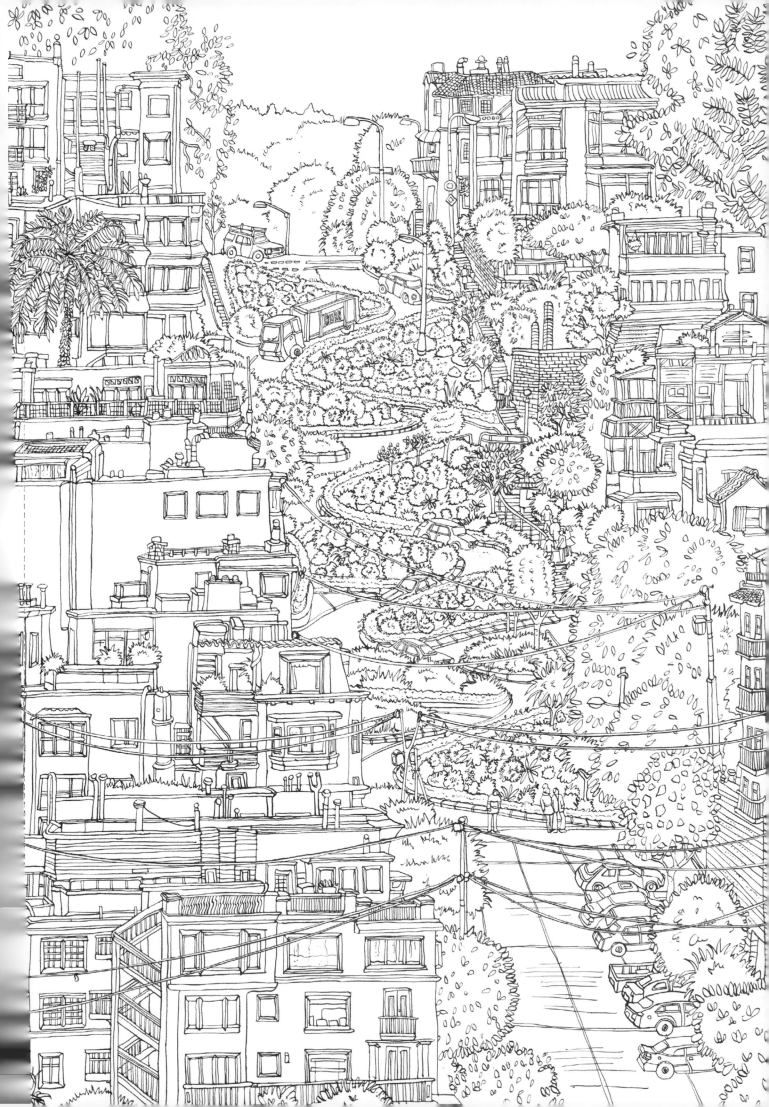

previous page

8.

Lombard Street

San Francisco is famously hilly, and its steeper sections have posed
plenty of challenges for town planners over the years. One of the
more extreme solutions can be seen in a single block of Lombard
Street in the Russian Hill neighborhood—its switchback curves,
introduced in the 1920s, have earned it the title of "the crookedest
street in the world." The eight sharp curves were originally introduced
by planners for safety reasons—they make it impossible for cars to
accelerate down the hill—but the unintended result is that the street
is one of the most-photographed sites in the city.

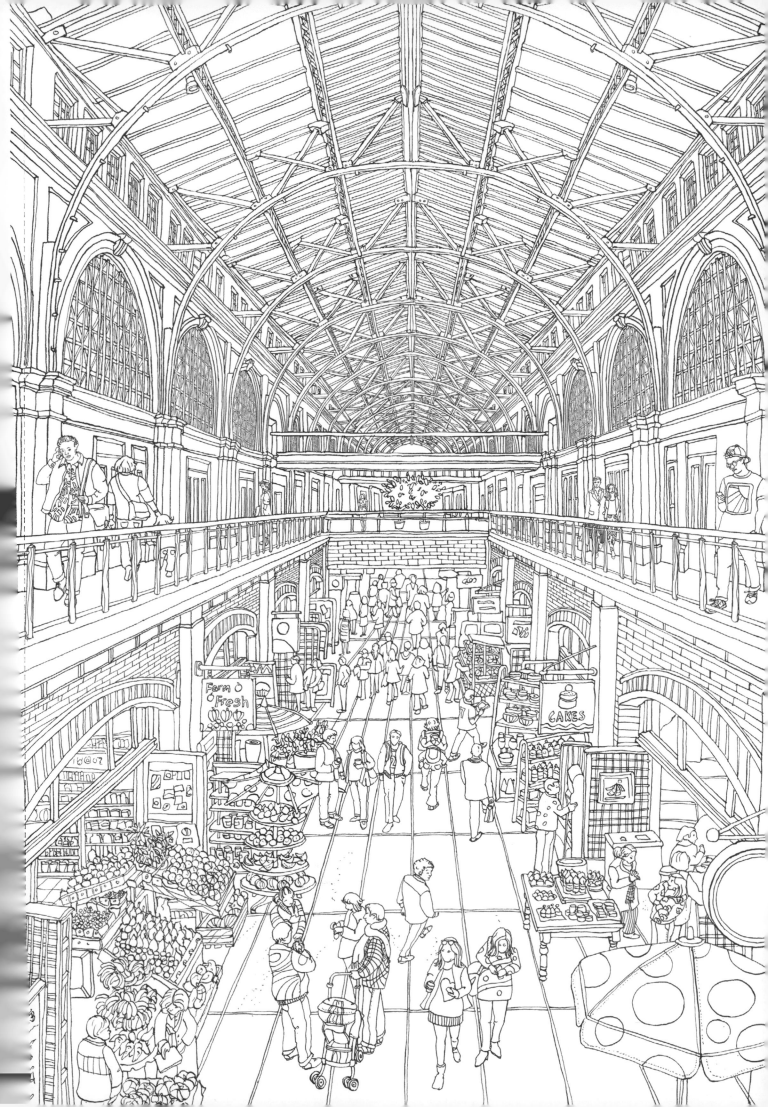

previous page

9.

Ferry Plaza Farmer's Market

Opened in 1898, the Ferry Building is set on the eastern waterfront of San Francisco's port area. The long, arcaded structure—which in its heyday saw tens of thousands of commuters pass through its doors each day—survived the earthquake and fire of 1906, as well as the gradual lessening of port traffic after first the Bay Bridge and then the Golden Gate Bridge were built. Inside is an impressive double-height space, which hosts the most popular farmer's market in the city three times a week on Tuesdays, Thursdays, and Saturdays, offering everything from organic fruit and vegetables to regional artisanal products. Thursdays also feature all kinds of street food vendors, and Saturdays offer the extra inducement (if one were needed) of pop-up restaurants from a number of local producers and chefs.

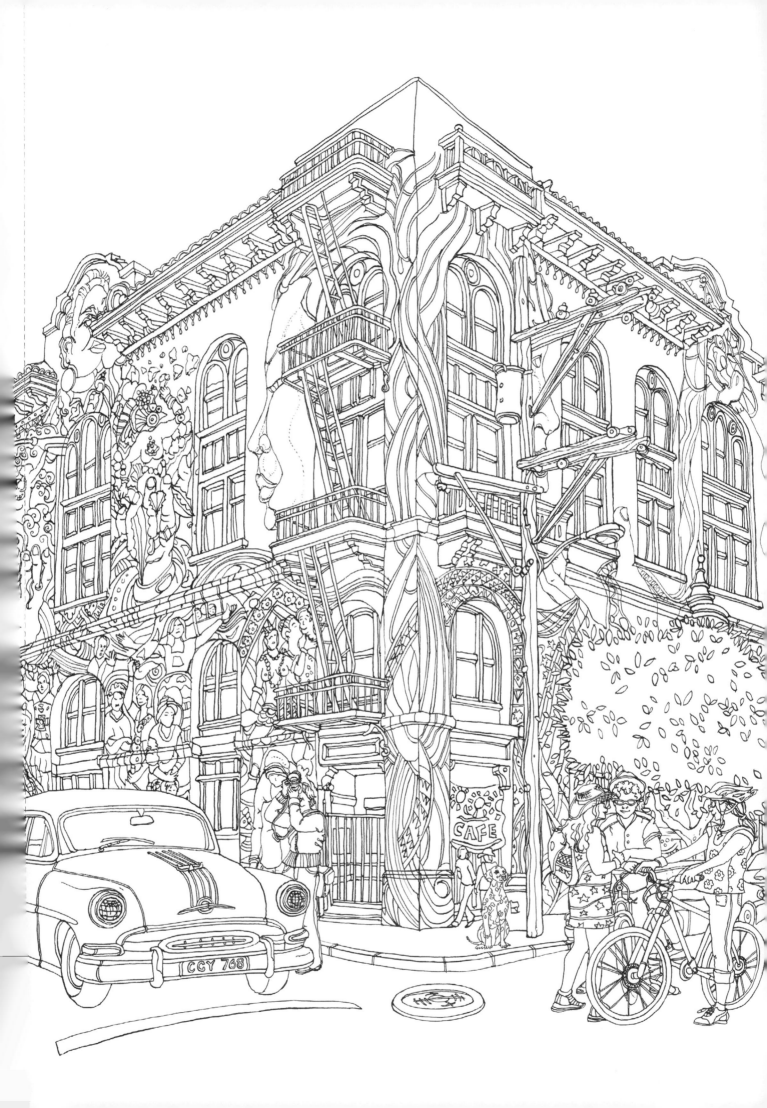

previous page

10.

Women's Building, Mission District

Located in east-central San Francisco, the Mission District is so-called because it was where the first Spanish missionaries to arrive in the area set up their ministries in the late eighteenth century. Today it's one of the city's most popular areas, and one of its must-see attractions is the Women's Building, located on the corner of 18th and Lapidge Streets. It has served as a center for the Bay Area women's projects since 1979, and its most striking feature is the all-over decoration—known as the MaestraPeace Mural—that reaches the full height of the building. Painted by seven local muralists, it features dozens of dynamic females, including goddesses, freedom fighters, and Laureates. There's just one male figure included: Delexis Boone, the son of one of the artists—visitors spend time hunting him out.

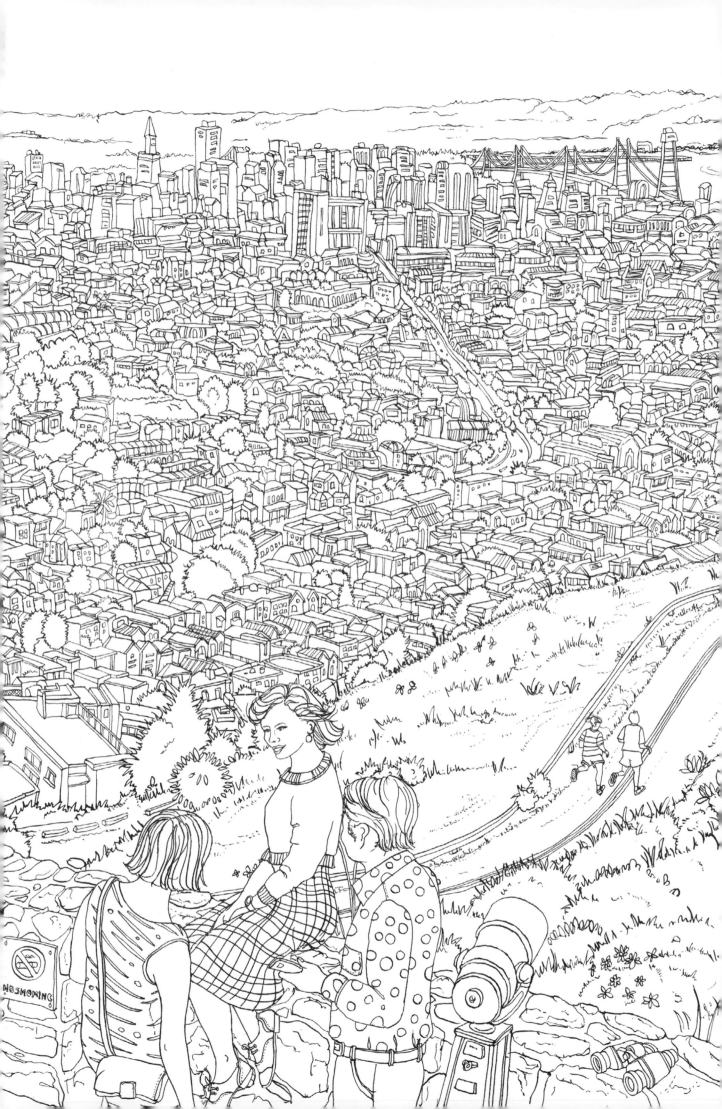

previous page

11.

Twin Peaks

With its sharply undulating landscape, there are plenty of
vantage points in San Francisco where you can get a good view.
There's no arguing about where to find the best, though: it's to
be had from the Twin Peaks, two adjacent hills located more or
less in the geographic center of town. The north peak is named
"Eureka" and the south peak "Noe"; at 925 feet (282 m), they're
a short but steep climb, and at the top you'll find a 360-degree
view in which you can pick out every landmark in San Francisco.
If you're lucky you might also be treated to the eerie view of
fog creeping over the city; on days when everything is already
shrouded, the summits of the Twin Peaks sometimes remain
above the fog, leaving you with the slightly disconcerting
impression that you're in a plane, looking down on the clouds.

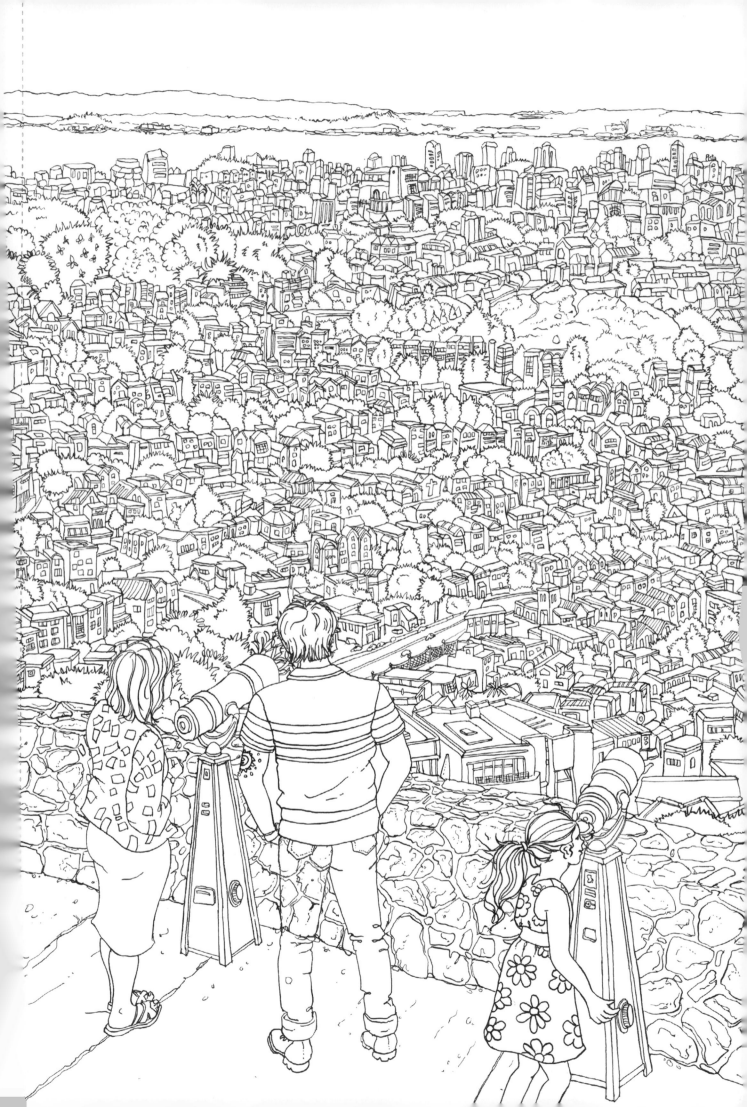

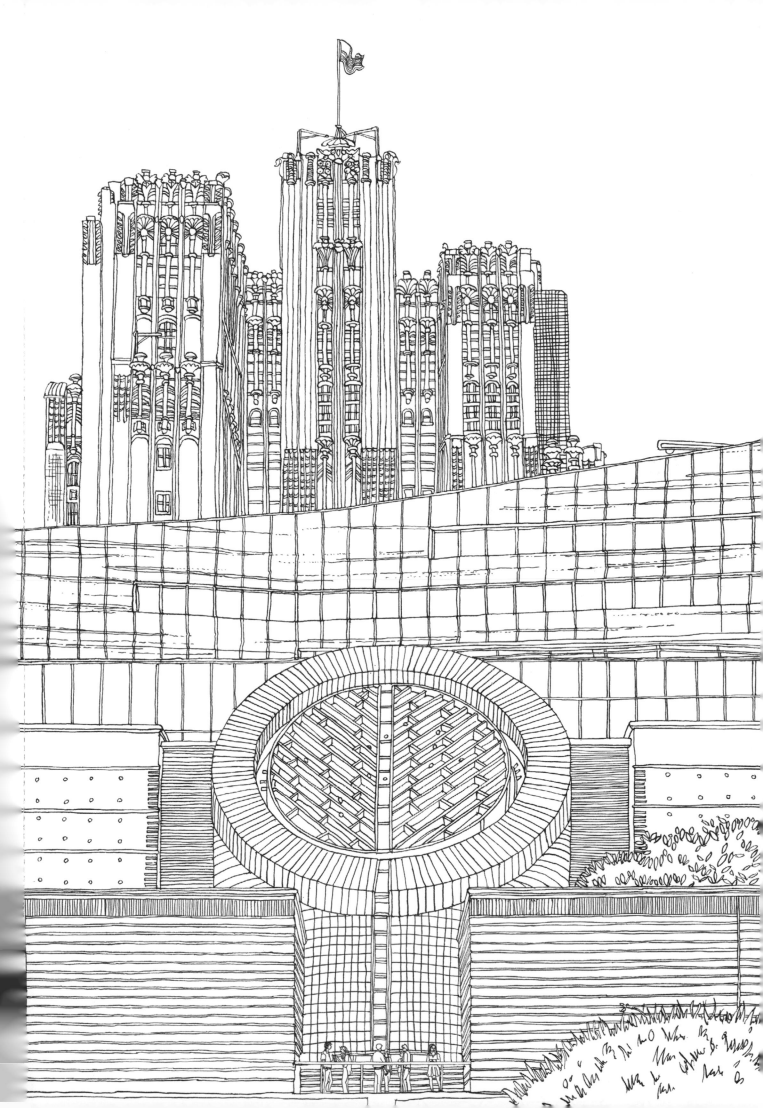

previous page

12.

San Francisco Museum of Modern Art

Since its reopening in 2016, after a three-year closure for expansion, the San Francisco Museum of Modern Art (SFMOMA) has become one of the largest art museums dedicated to contemporary work anywhere in the world. It was founded in 1935 at 401 Van Ness Avenue before moving in 1995 to a new building on Third Street between Mission and Howard Streets. This was designed by Mario Botta and it features a striped brick facade opening to reveal a cylinder made of gray and white marble. The 2016 extension, ten stories high and placed behind the original building, was designed by the international architecture and design company Snøhetta and resembles a huge, irregular iceberg—cementing SFMOMA's reputation as an innovator in museum buildings, as well as the guardian of a world-renowned collection.

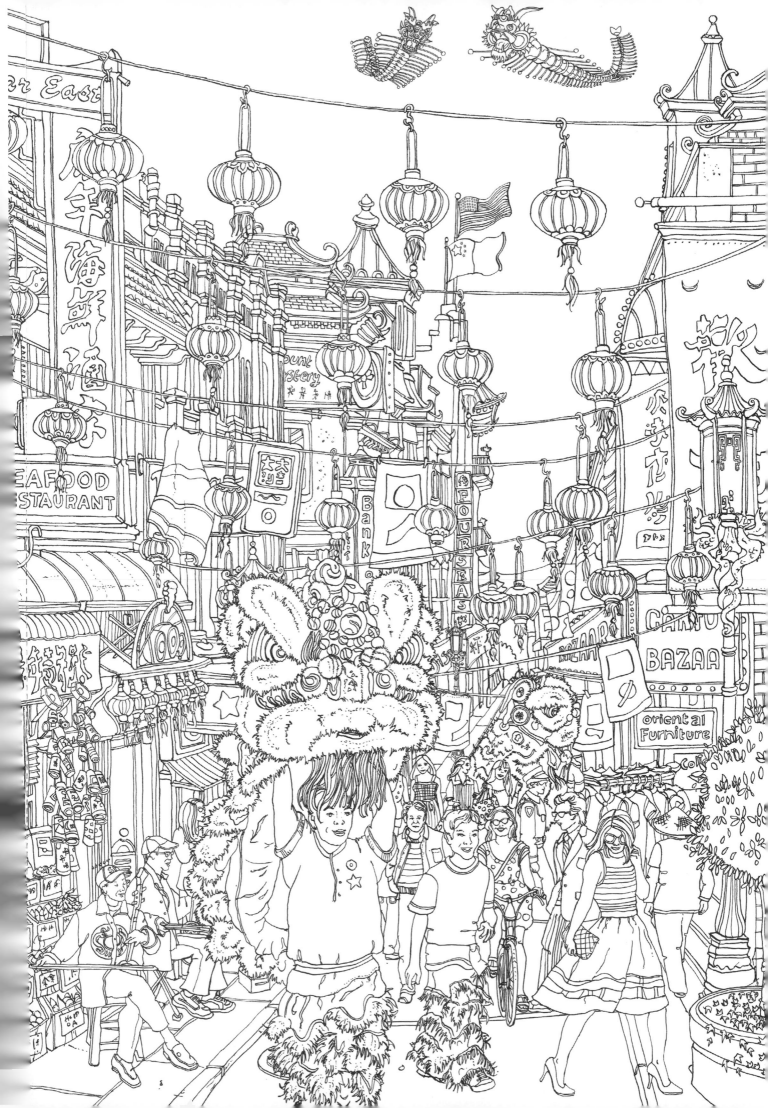

previous page

13.

Chinatown

San Francisco's Chinatown has long been known as the largest Chinese community outside Asia. The first Chinese people to arrive on the West Coast in numbers came to work on the construction of the Transcontinental Railroad. The fortunes of the community rose and fell: like many other areas in the city, the Chinese quarter was flattened by the 1906 earthquake, and there were also problems with organized crime and drugs. However, with the 1960s came a new influx of arrivals from Hong Kong, and the reputation of Chinatown's restaurants, temples, and clubs gradually began to grow. Today the original area, in the northeast of the city around Grant Avenue and Stockton Street, is a favorite with visitors, especially at festival times, such as Chinese New Year or the Mid-Autumn Moon Festival. Festivals and holidays offer spectacles on the streets—in particular the lively dragon dance, performed in a hail of firecrackers.

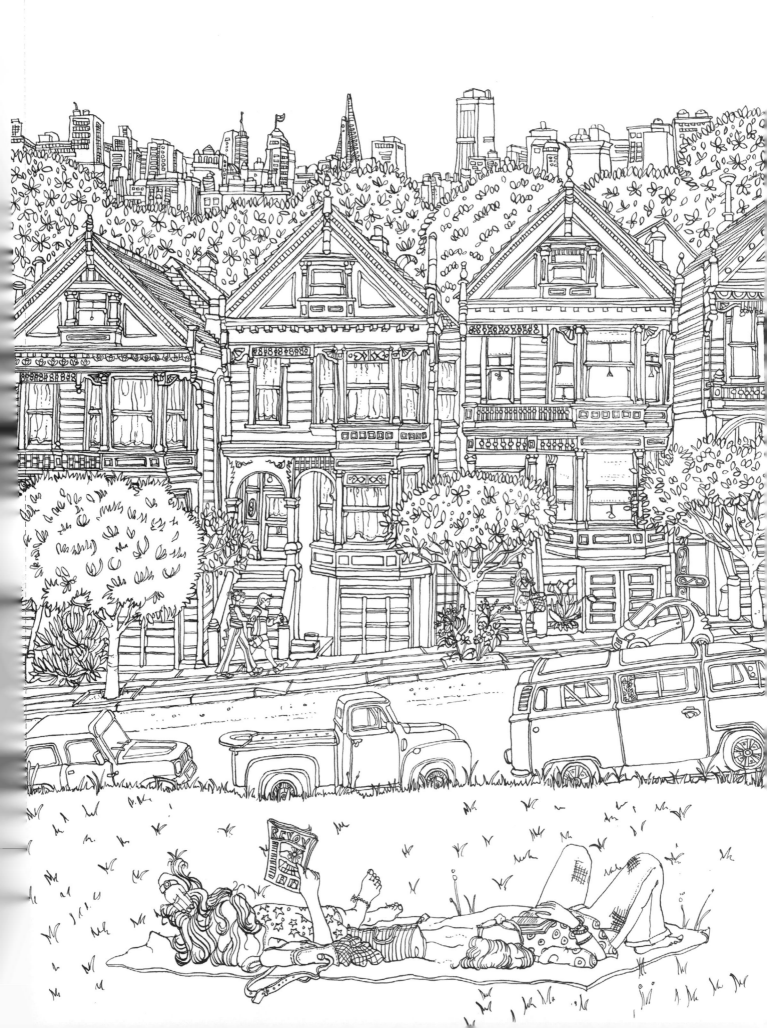

previous page

The Painted Ladies of San Francisco

San Francisco's "Painted Ladies" are the seven elegant Victorian houses on Steiner Street, across from grassy Alamo Square. Built in the second half of the nineteenth century, with gingerbread molding around their pointed eaves and elaborately detailed balconies, they somehow survived earthquake and fire to become some of the most highly valued (in both senses) homes in the city. Originally a Quakerish gray, in the 1960s it became the fashion to paint them a range of contrasting pastels, and today they are mostly beautifully bright and immaculately maintained. Look over their rooftops and you'll be rewarded with a fantastic panorama of the high-rise area of the city stretching out into the distance beyond.

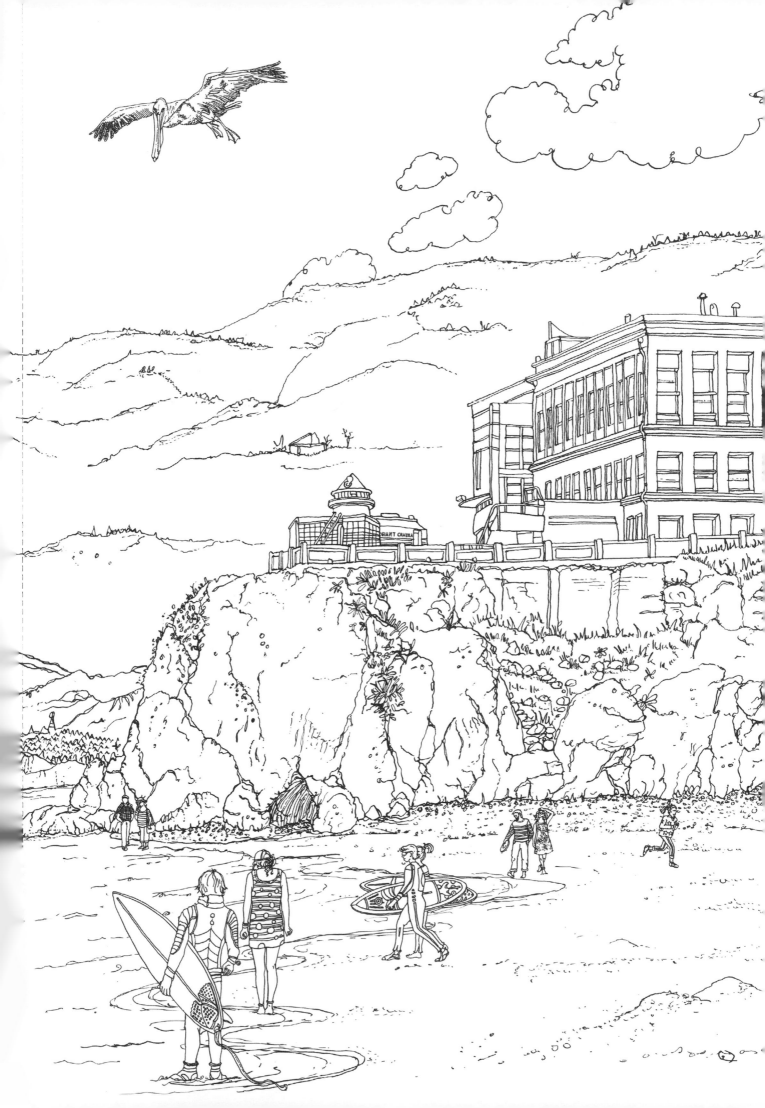

previous page

15.

Ocean Beach

Native San Franciscans will tell you that you don't move there for the climate, and they're right: the famous fog can make a carefree day at the beach unexpectedly chilly, and the city doesn't have a beach culture comparable with that of southern California. No matter— Ocean Beach, to the west of the city facing directly onto the Pacific, has plenty of fans. It's popular with surfers and anyone who's happy to take a sweater along for a day out, and at 3.5 miles (5.6 km) long, it doesn't tend to get too crowded. Sand, sea, and breezes are all delightfully clean, but swimming is risky; there are strong rip currents, so only experienced surfers should brave the water. If you don't have the nerve, light up a barbecue and cook a beach picnic instead.

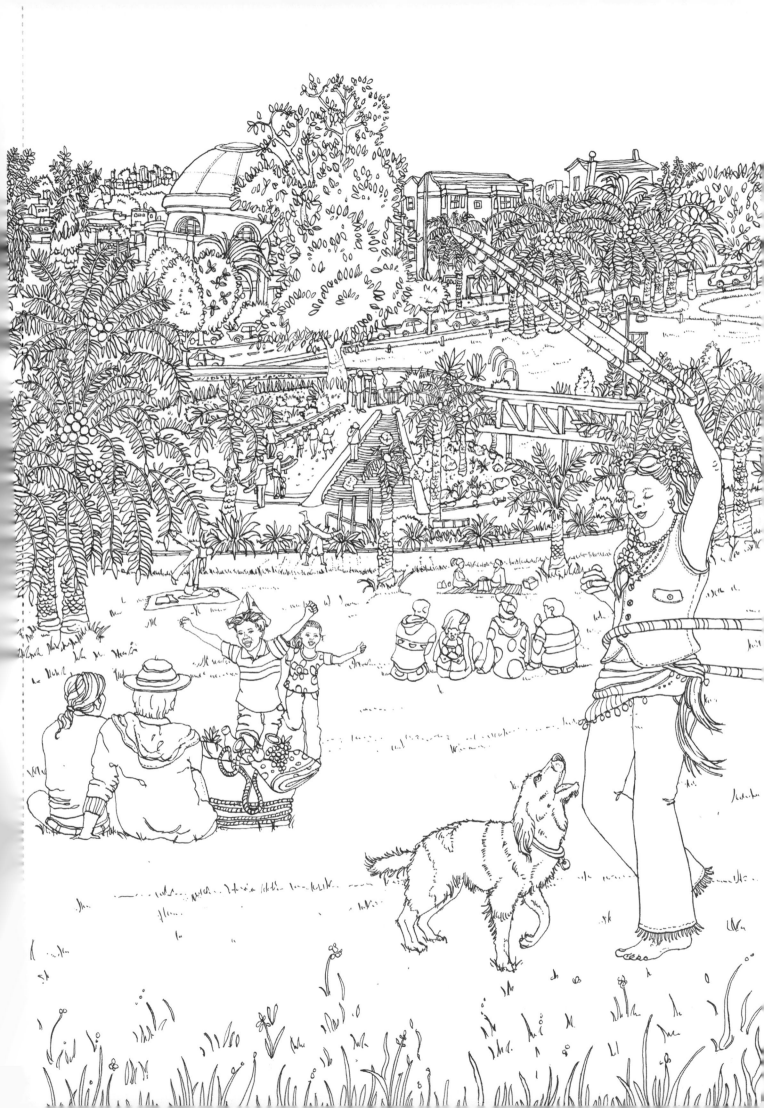

previous page

16.

Mission Dolores Park

It's got a varied history—in times past it was a Jewish cemetery and then later Barnum & Bailey's celebrated circus performed on the site—but today Dolores Park, located along the western edge of the Mission District, is thriving. Just sixteen acres in size, the park reopened in 2016 after undergoing substantial refurbishment. What can you do there? Anything you like, within reason: it's popular with dog walkers, Frisbee players, picnickers, and potheads; in summer, it hosts movie nights and performance art too. The hilly southwest corner makes a great vantage point for people-watching: sit at the top of the slope to get a bird's-eye view of everything that's going on.

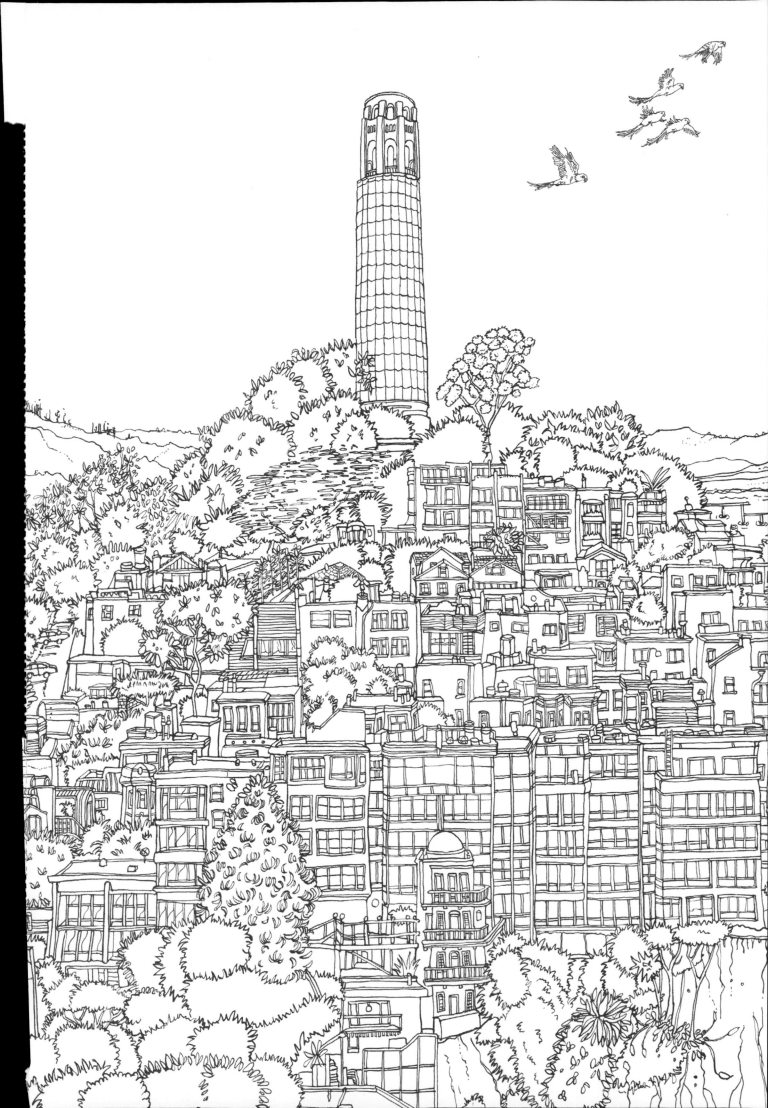

previous page

17.

Coit Tower

Named for its patroness, the eccentric San Franciscan heiress Lillie
Hitchcock Coit, the Coit Tower was built in 1933, a simple concrete
column in a broadly art deco style with arched open galleries at its
summit. Lillie had wanted a memorial for the city to remember her by,
and her tower certainly fills the bill. Located at the top of Telegraph
Hill (inhabited by a population of bright green-and-red parrots), set
squarely between Fisherman's Wharf and San Francisco's financial
district, it is surrounded by Pioneer Park, a dedicated green area kept
safe from development. Not only is the outside of the tower elegantly
simple, but the curved walls inside are lined with murals, executed in
the 1930s by students and teachers at the California School of Fine
Arts, showing scenes of everyday life—some of them unflinching
depictions of hardship during the Great Depression. Mural tours
can be arranged by appointment.

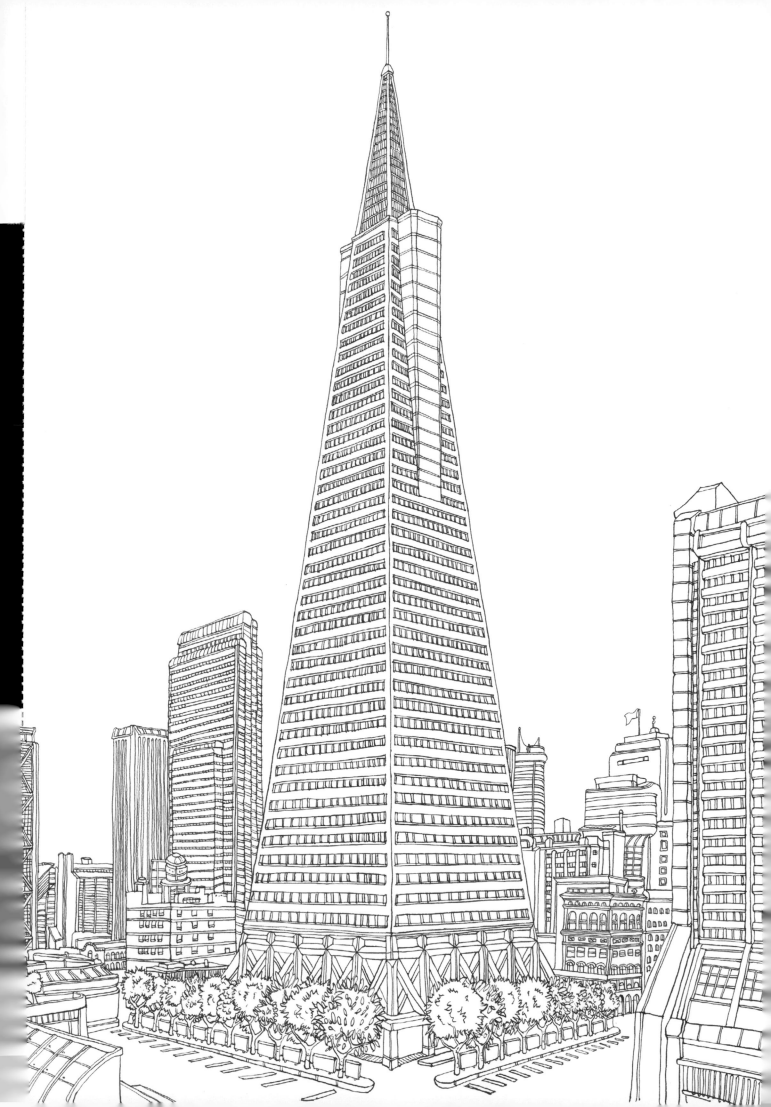

previous page

18.

Transamerica Pyramid

In its time, the soaring white-quartz needle of the Transamerica
Pyramid, designed by William Pereira, was the acme of modernity.
Completed in 1972, it was the tallest skyscraper in San Francisco
at 853 feet (260 m) for well over forty years. It seems both modern
and of its time, and although it hasn't been the headquarters of the
Transamerica Corporation for a while, it has retained its grandiose
name. The wing-like structures high on its shoulders house an
elevator on one side and stairs on the other. And why the dramatically
narrowing shape? Pereira claimed that it allowed more light down
to street level, avoiding the "canyon" effect caused by the boxy
skyscrapers in cities such as New York.

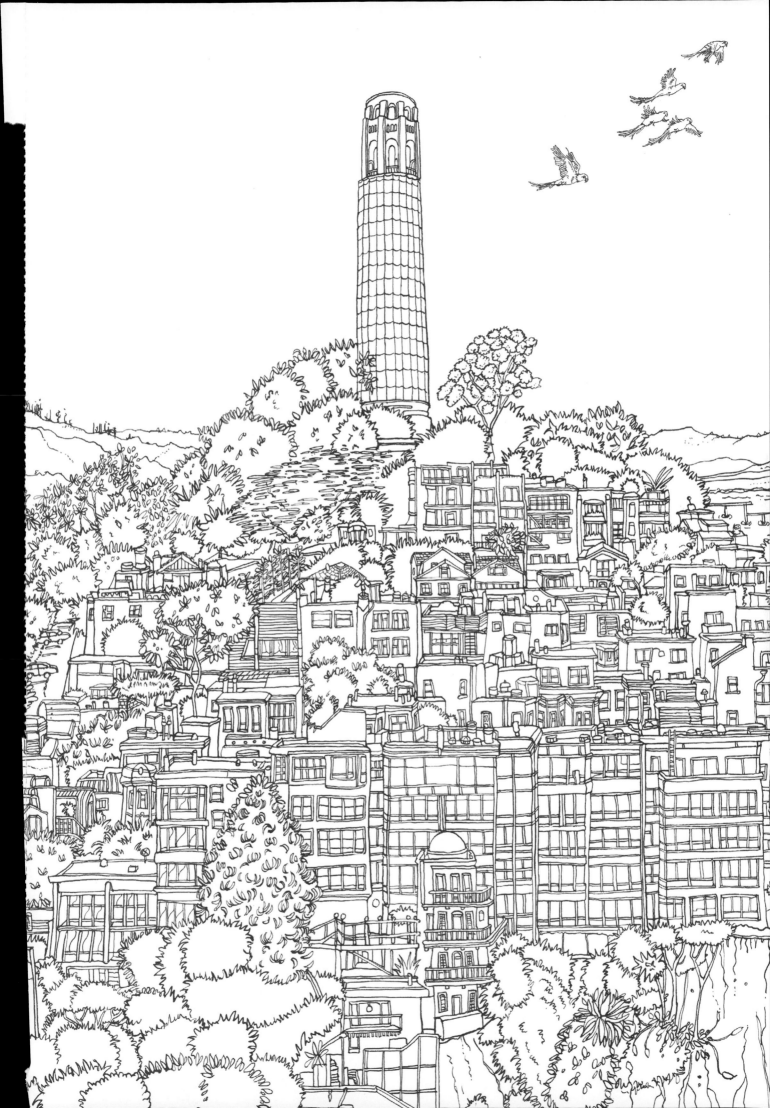

previous page

17.

Coit Tower

Named for its patroness, the eccentric San Franciscan heiress Lillie
Hitchcock Coit, the Coit Tower was built in 1933, a simple concrete
column in a broadly art deco style with arched open galleries at its
summit. Lillie had wanted a memorial for the city to remember her by,
and her tower certainly fills the bill. Located at the top of Telegraph
Hill (inhabited by a population of bright green-and-red parrots), set
squarely between Fisherman's Wharf and San Francisco's financial
district, it is surrounded by Pioneer Park, a dedicated green area kept
safe from development. Not only is the outside of the tower elegantly
simple, but the curved walls inside are lined with murals, executed in
the 1930s by students and teachers at the California School of Fine
Arts, showing scenes of everyday life—some of them unflinching
depictions of hardship during the Great Depression. Mural tours
can be arranged by appointment.

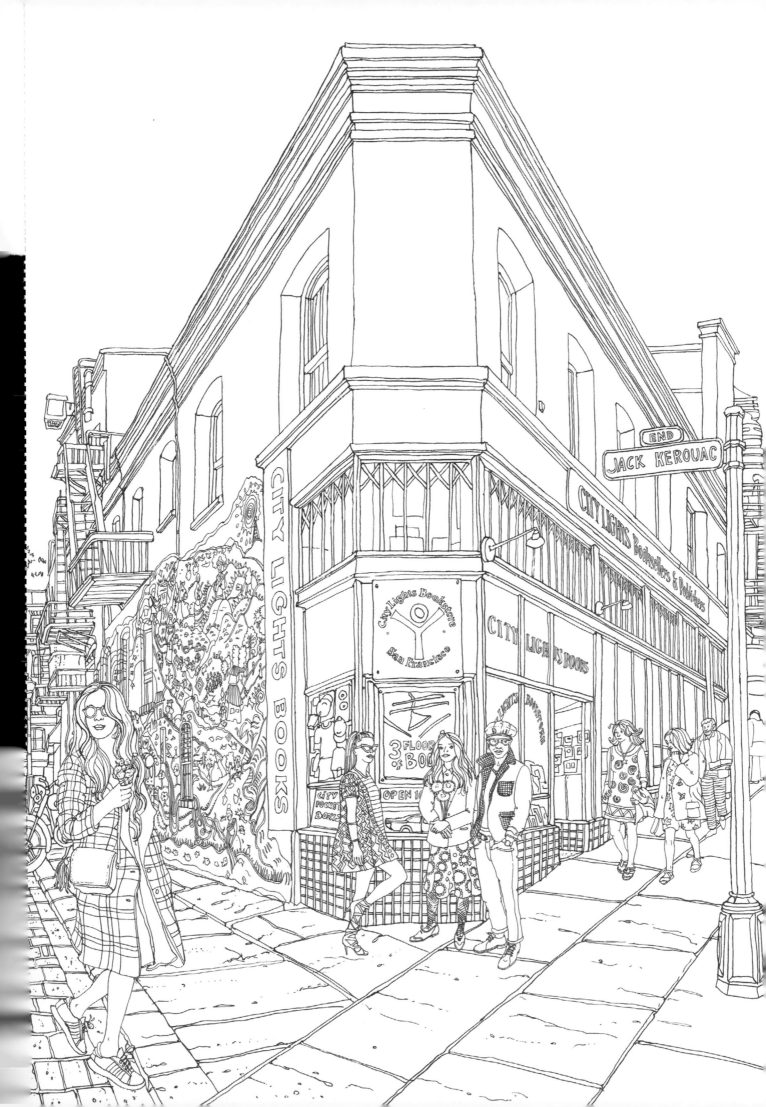

previous page

19.

City Lights Bookstore

Despite its fairly unassuming street facade at 231 Columbus Avenue, the City Lights bookstore famously carries its intellectual weight. Founded in 1953 by the avant-garde poet Lawrence Ferlinghetti and his business partner Peter D. Martin, on a seed investment of $500 each, it acted both as bookstore and publisher—at that time a novel concept—and was the sole paperback-only bookstore in the United States. Employees were chosen on the grounds of their book knowledge and literary interests rather than for commercial concerns. City Lights hit the headlines in 1956, when Ferlinghetti published Allen Ginsberg's poetry collection *Howl and Other Poems* and was prosecuted for obscenity. The case was overturned the following year, and Ginsberg's work has since attained the status of an American classic. Today the store carries an unusually eclectic selection of stock arranged over three floors—something for everyone, particularly for those favoring political and progressive writing.

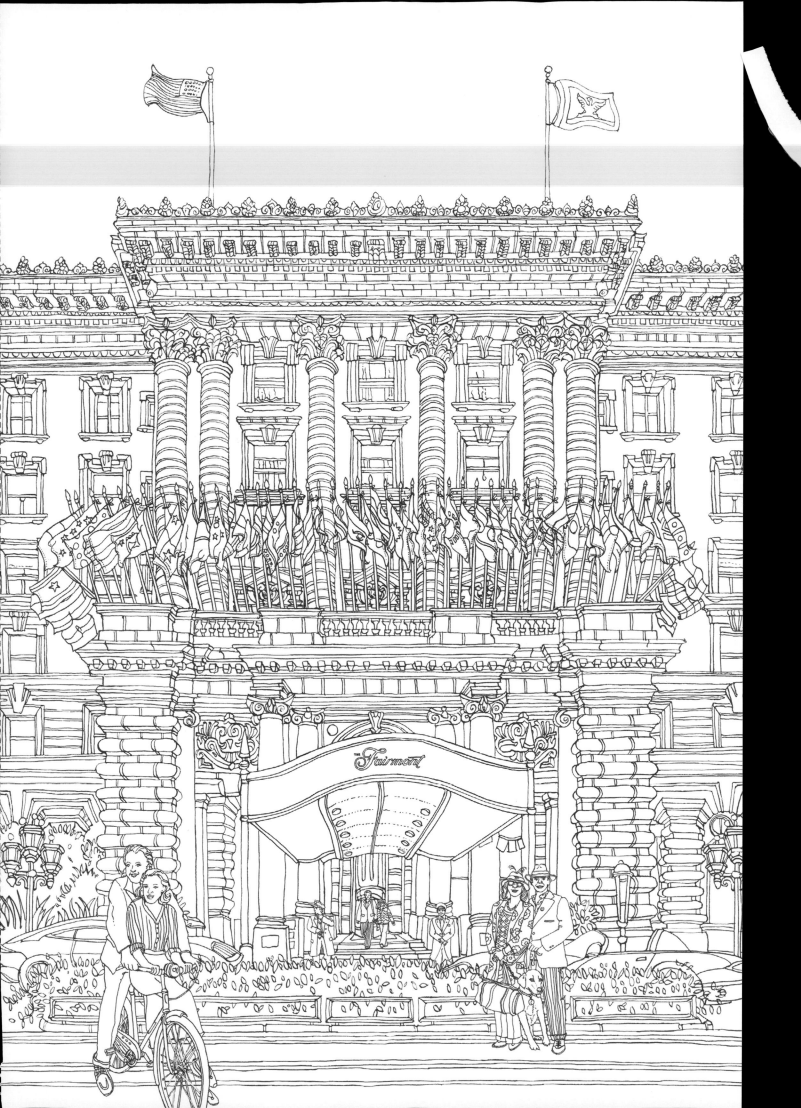

previous page

20.

Fairmont Hotel, Mason Street

Although the Fairmont has an illustrious past, it didn't get off to
the best of starts: the building was almost completed when the
1906 earthquake struck, and it took another year of repairs (including
the innovative use of reinforced concrete) before it finally opened
in 1907. Daringly, the owners selected a woman architect to manage
the repairs and finish the building—Julia Morgan, who had just
completed her studies at the École des Beaux Arts in Paris. It was
generally agreed that she was triumphantly successful: the opening
party was as extravagant as the new hotel was elegant, featuring
fireworks and a supper that included 13,000 oysters, 600 pounds
(272 kg) of turtle meat, and an array of French wines. The Fairmont
has had its ups and downs since then—high points have included
hosting a first performance of "I Left My Heart in San Francisco"
crooned by Tony Bennett—but it remains a San Francisco institution
and one of its most luxurious hotels.

previous page

19.

City Lights Bookstore

Despite its fairly unassuming street facade at 231 Columbus Avenue, the City Lights bookstore famously carries its intellectual weight. Founded in 1953 by the avant-garde poet Lawrence Ferlinghetti and his business partner Peter D. Martin, on a seed investment of $500 each, it acted both as bookstore and publisher—at that time a novel concept—and was the sole paperback-only bookstore in the United States. Employees were chosen on the grounds of their book knowledge and literary interests rather than for commercial concerns. City Lights hit the headlines in 1956, when Ferlinghetti published Allen Ginsberg's poetry collection *Howl and Other Poems* and was prosecuted for obscenity. The case was overturned the following year, and Ginsberg's work has since attained the status of an American classic. Today the store carries an unusually eclectic selection of stock arranged over three floors—something for everyone, particularly for those favoring political and progressive writing.

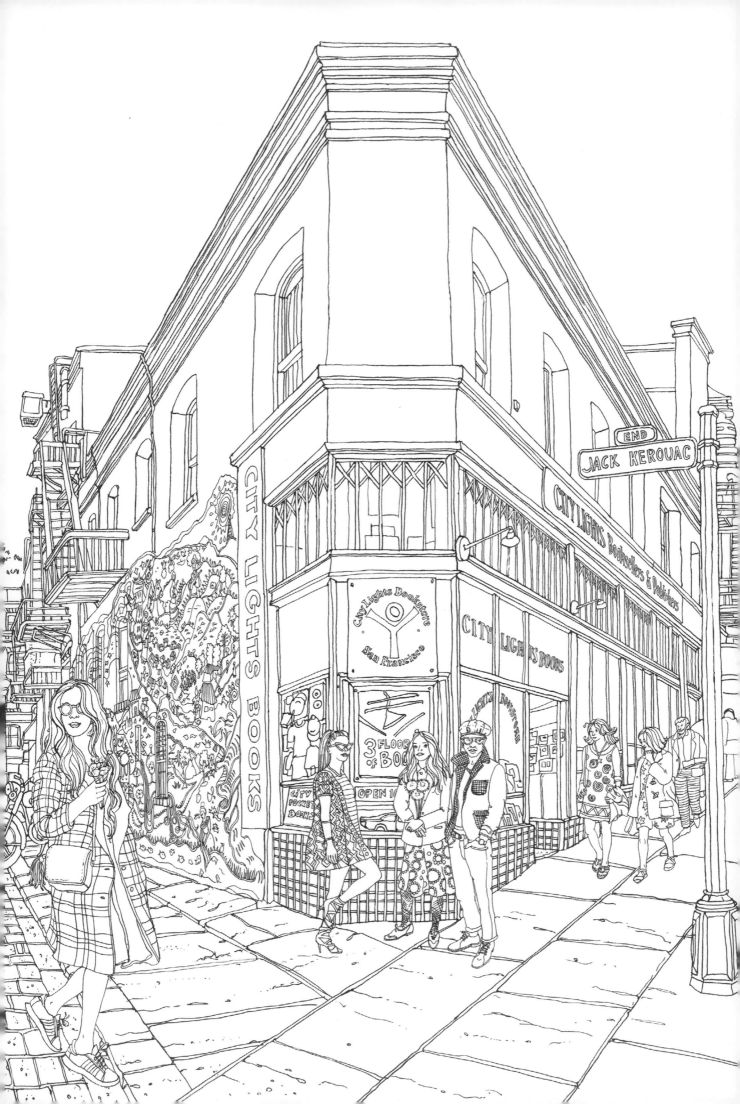